DROPPING IN ON ROMARE Bearden

By Pamela Geiger Stephens
Illustrations by Jim McNeill

CrystalProductions
Glenview, Illinois

Library of Congress Cataloging-in-Publication Data

Stephens, Pamela Geiger.
 Dropping in on Romare Bearden / by Pamela Geiger Stephens ; illustrated
by Jim McNeill.
 p. cm.
 ISBN 978-1-56290-539-2
 1. Bearden, Romare, 1911-1988—Juvenile literature. I. McNeill, Jim, 1967-
II. Title.
 N6537.B4S72 2007
 709.2—dc22
 2007018440

ISBN 978-1-56290-539-2

Printed in Hong Kong

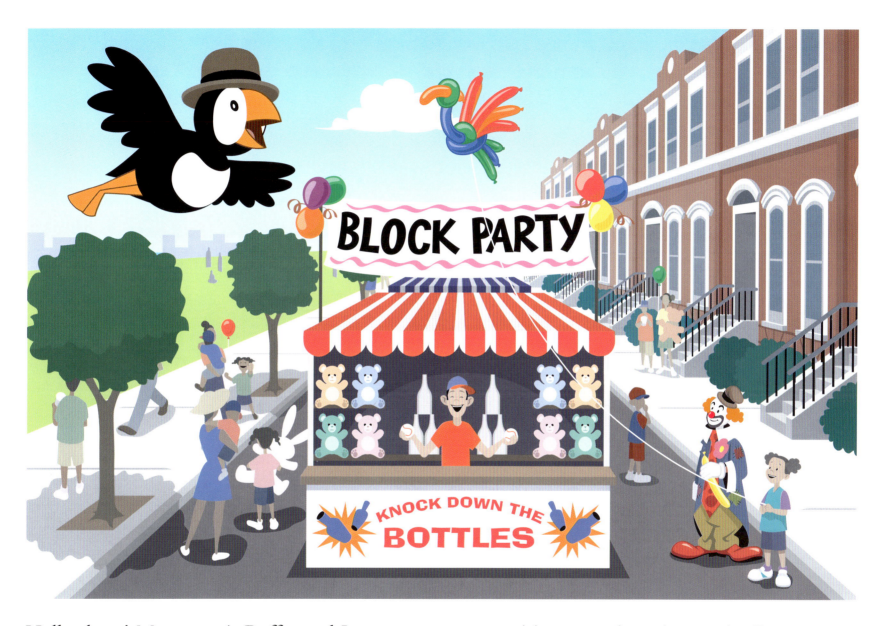

Hello there! My name is Puffer and I am on my way to visit a great American artist, Romare Bearden.

Mister Bearden lives in New York City. Would you like to come along with me?

As Puffer flies over the city, he hears the sounds of music and laughing. It sounds like a party!

A balloon animal floats up to the sky. Puffer is polite and tips his hat.

"Hello!" he says.

Puffer loses his balance and falls from the sky.

W
 H
 O
 A
 A
 A
 A

Flutter! Flap! Flap! Flap! Flutter! Flap!

Crash! Bump! Thump!

Puffer falls into a booth where games are being played.

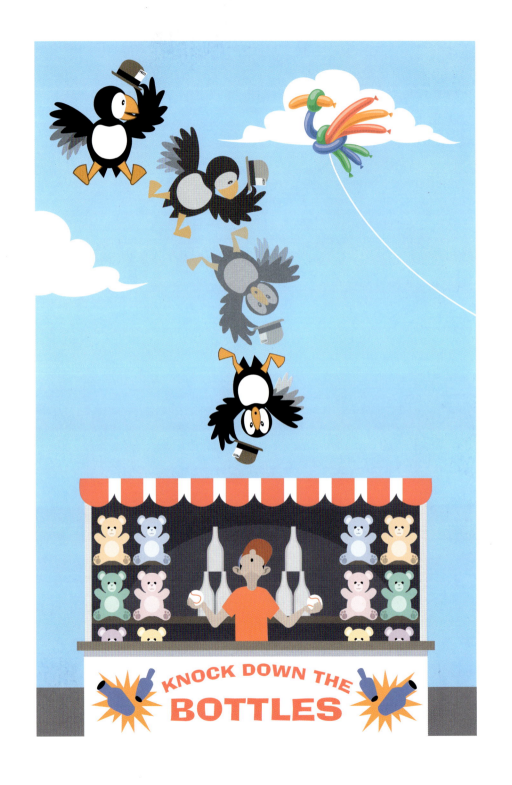

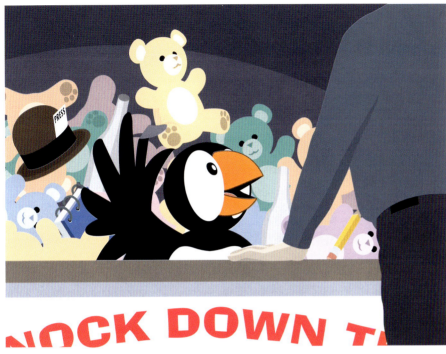

"Pardon me, sir. Do you know where I can find Mister Romare Bearden?"

"Of course I know where you can find him," the man laughs. "I *am* Romare Bearden!"

"I'm pleased to meet you, Mister Bearden!"

Puffer tips what he thinks is his hat.

"You must be Puffer. I've been waiting for you," says Mister Bearden.

Mister Bearden helps Puffer out of the booth.

They walk a few blocks to Mister Bearden's studio.

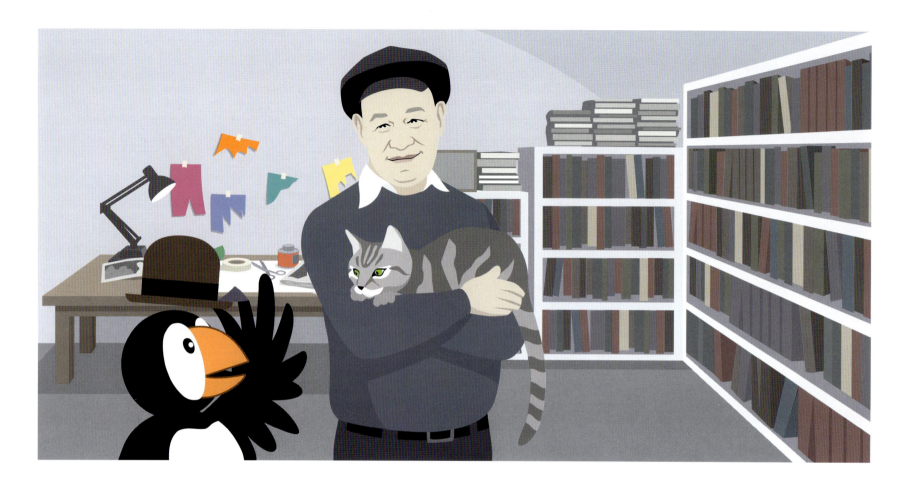

"Welcome to my studio, Puffer," says Mister Bearden. "Make yourself at home."

Puffer looks around before he says, "You have so many books!"

"I love to read," says Mister Bearden. "Reading is the perfect way to learn new ideas."

"Whoops!" exclaims Mister Bearden, "I almost forgot to introduce you to my cat Gypo."

"Hello, Gypo. It's nice to meet you."

"Meow," Gypo replies.

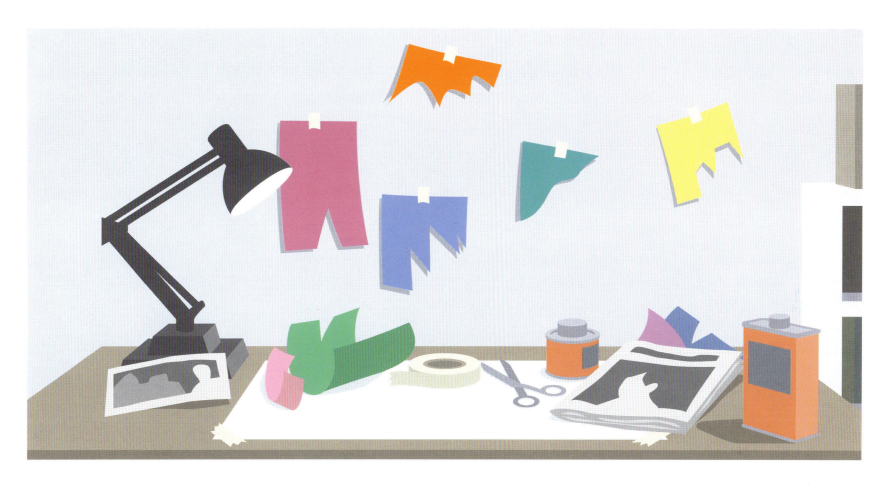

"What are those things on the table, Mister Bearden?"

"That is what I use to make collages," Mister Bearden answers. "A collage is a kind of art that is made by cutting out pictures and shapes from things like magazines, newspapers, and other kinds of paper and making a composition with them."

"I'd like to see a collage!"

"Then, let's look at one now," says Mister Bearden.

"The title of this collage is *The Conversation,*" begins Mister Bearden. "Do you see shapes that I have cut from paper and glued together?"

"Indeed I do! It's easy to see that the shapes of the two ladies are cut from solid black paper. Their dresses are cut from paper that has designs on it."

"Very good!" says Mister Bearden.

"There are other shapes cut from paper, too. I think the house, the train, and the telephone poles all look as if they have been cut from paper."

"Right again," Mr. Bearden tells Puffer. "Almost everything in the collage has been cut from paper and glued together."

"Even tiny details?"

"Even tiny details," replies Mister Bearden.

"It must take a long time to make a collage."

"That is true, Puffer," Mister Bearden says. "Maybe you would like to make a collage yourself."

"Sure! I'd like that a lot!"

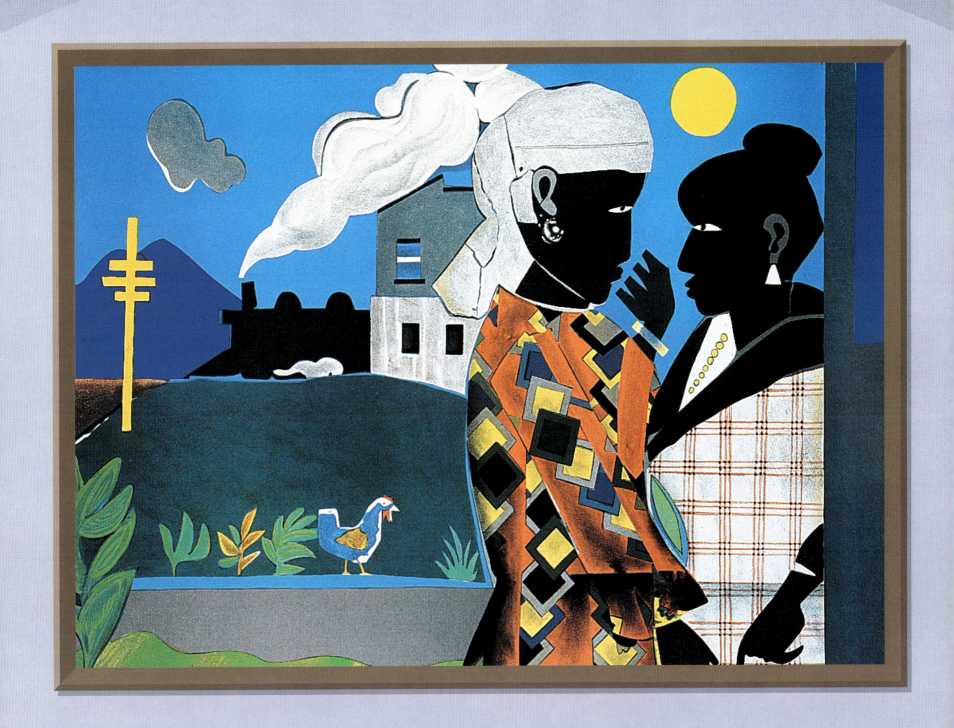

Mister Bearden points to some supplies. "Here are some things that you can use to make a collage."

Puffer sees different kinds of paper, magazines, newspapers, scissors, glue, markers, and paint.

"You could use other things like string, cardboard, or foil," adds Mister Bearden. "Artists use all sorts of materials to make collages."

"When you have an idea for your collage, a good way to start is to cut out a shape from paper," explains Mister Bearden.

"Now choose another paper for the background," Mister Bearden says.

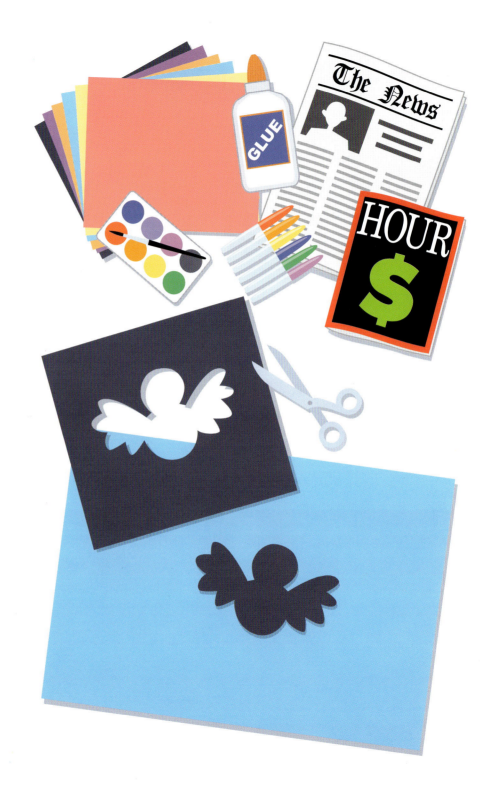

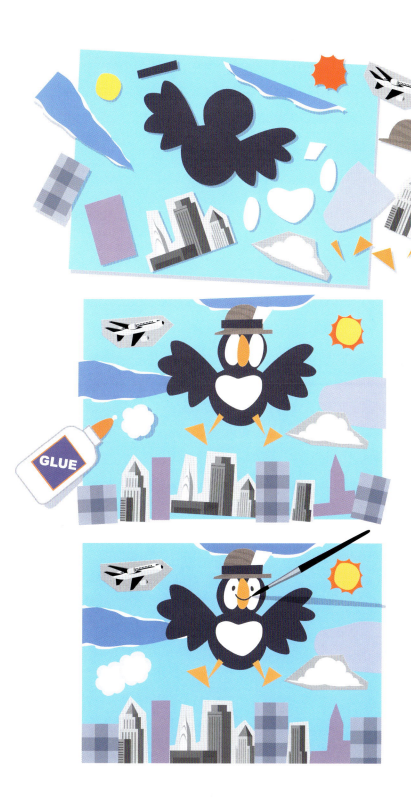

"Next, cut out some other shapes," Mister Bearden tells Puffer, "and then move them around until you like the way everything fits together."

Puffer moves the shapes around until they are just the way he wants them. "There! I like the way this looks!"

"Okay," says Mister Bearden. "Glue the shapes to the background. When all of the glue is dry, you can add more details with markers or paint. You can even use materials like wrapping paper or cloth."

"Making a collage is loads of fun, Mister Bearden!"

Mister Bearden agrees. "I thought you'd like it," he says. "Maybe you'd like to see another of my collages now."

"That would be terrific!"

"The title of this collage is *Early Carolina Morning*," Mister Bearden says as he points to a collage on the wall. "What do you see in this picture, Puffer?"

"First, I see that this picture is inside of a house."

"Who do you see in the picture?" asks Mister Bearden.

"There are two people. I see a lady and a little child. They must be getting ready for the day. The lady seems to be talking to the child. I wonder what she is saying."

"That is for you to decide," answers Mister Bearden. "Look closely at the house. What do you see?"

"There are lots of little details like a picture on the wall and a checkered floor. I also see a cat."

"The shape of the cat balances the picture," explains Mister Bearden. "You'll see cats and trains in many of my collages."

"You must like those things."

"Indeed I do," says Mister Bearden. "Indeed I do."

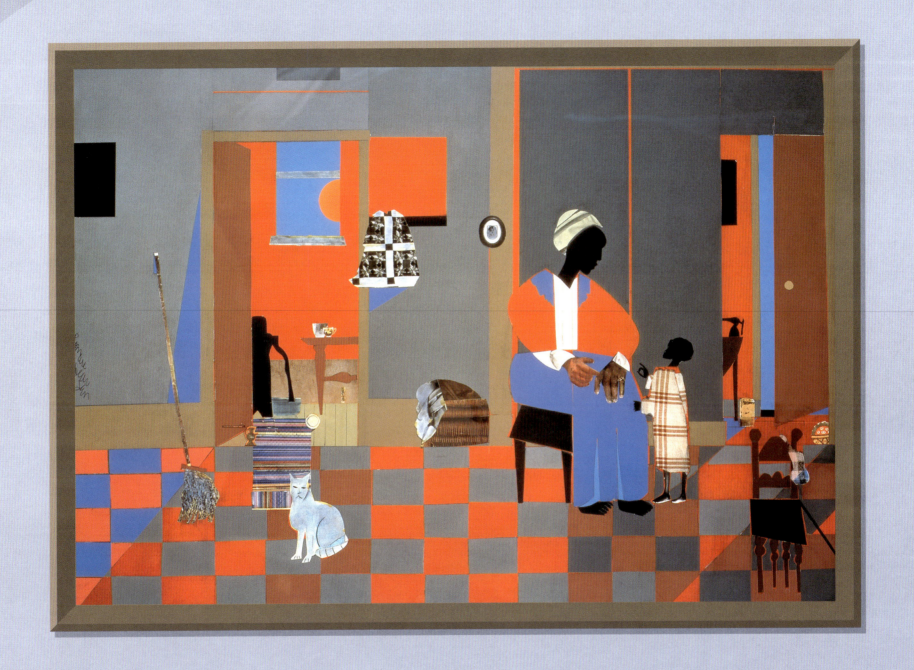

Puffer sees a photograph album and asks Mister Bearden if they can look at the pictures.

"Of course," replies Mister Bearden as he opens the book. Soon, Mister Bearden begins to tell the story of his life.

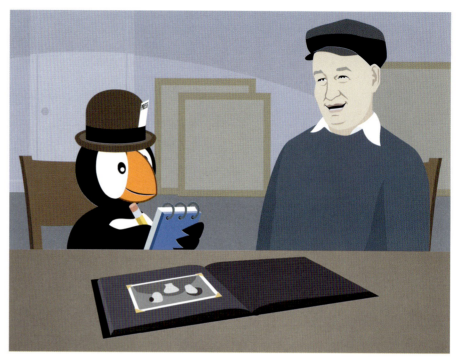

"I was born in Charlotte, North Carolina, in 1911," he says.

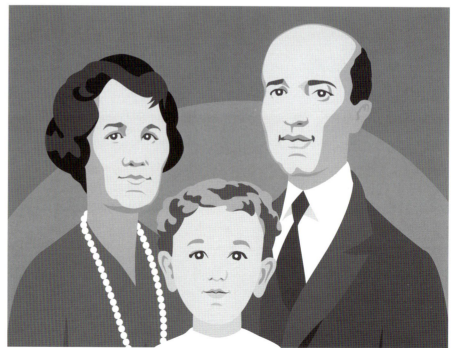

"When I was about three years old, my family moved to New York," Mister Bearden continues. "We lived in a place called Harlem."

"Harlem was an exciting place. There were artists, writers, and musicians everywhere!" exclaims Mister Bearden.

"My parents knew some famous people who often came to visit," Mister Bearden proudly tells Puffer.

"As exciting as Harlem was," says Mister Bearden, "I sometimes spent vacations with friends and family in other places. When I was in the fourth grade, I spent a whole school year with my grandparents in a city called Pittsburgh.

"Would you like to see a collage about my memories of Pittsburgh, Puffer?" asks Mister Bearden.

"Yes, please! That would be splendid!"

"Wow! In this collage, I can see the inside and the outside of a house at the same time!"

"What do you see inside of the house?" asks Mister Bearden.

"I see all sorts of things! There is a checkered rug, an open window, and an old-fashioned record player."

Mister Bearden nods. "And what do you see outside of the house?" he asks.

"It's a big house with blue windows. Behind the house are tall chimneys."

"Those chimneys are called smokestacks," explains Mister Bearden. "They are at the nearby factories. That's why you see fire and smoke coming out of them."

"Maybe the man who is walking away from the house is on his way to work in a factory," says Puffer. "I see that he has a shiny lunch pail."

"The lunch pail is made from a small piece of foil. Remember, all sorts of materials can be used to create a collage," adds Mister Bearden.

"What is the title of this collage, Mister Bearden?"

"*Pittsburgh Memories*," Mister Bearden answers. "Would you like to see one more collage about Pittsburgh?"

"Yes, please. I'd like that very much."

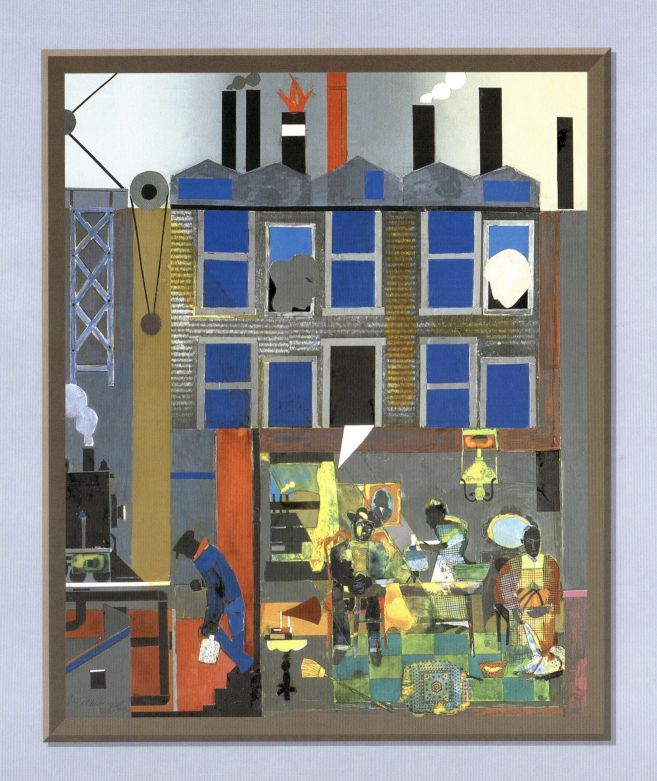

"I call this collage *Spring Way.* That is the name of the street near my grandparent's home," begins Mister Bearden. "Do you see a repeated shape in this collage?"

"That's easy to see! There are different sizes of rectangles everywhere!"

"I am happy that you saw the different sizes of rectangles," replies Mister Bearden. People sometimes say that my collages are like jazz."

Puffer looks puzzled. "I don't understand."

"Jazz is a kind of music. Jazz music often repeats an idea, but the idea is not always the same each time it is repeated." Mister Bearden explains.

"Like the different sizes of rectangles in *Spring Way*!"

"Yes! Just like the rectangles."

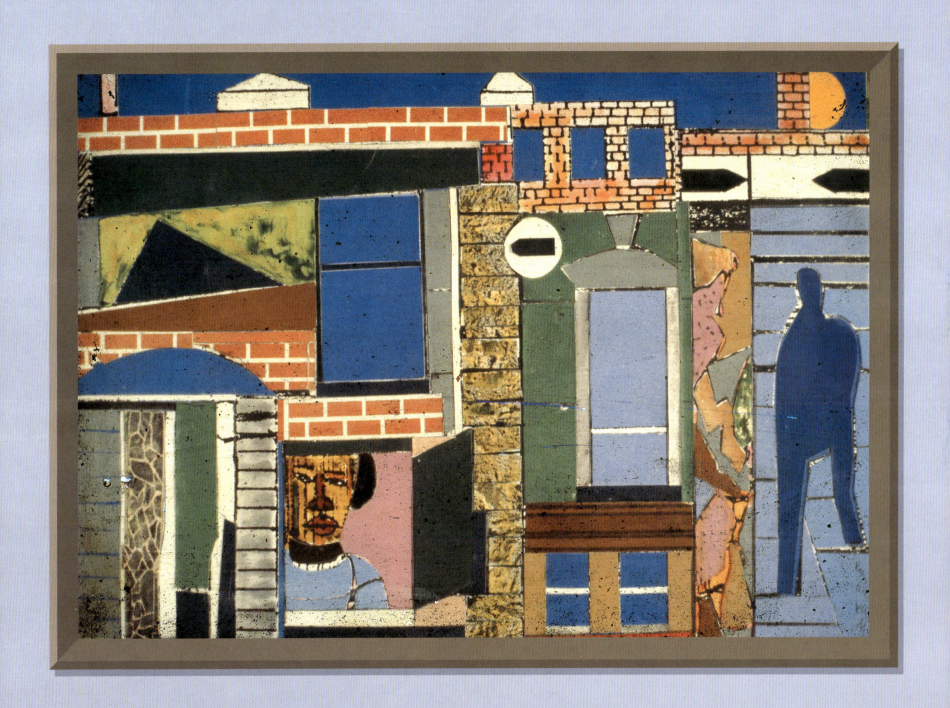

"Would you tell me a little more about your life, Mister Bearden?"

"Sure," Mr. Bearden says. Once again, Mister Bearden opens the photograph album and points to pictures as he talks.

"I had a friend named Eugene who lived in Pittsburgh. He taught me a little about drawing.

"After I came back to New York, I drew some posters that won a contest. My prize was $25 and a free movie pass for a whole year!

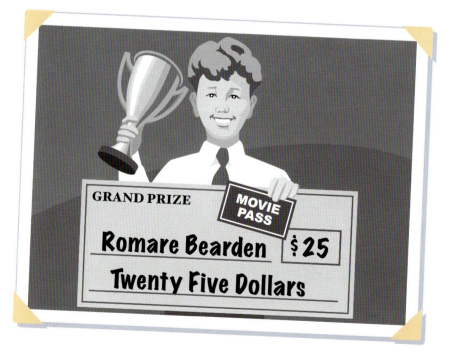

"In college, I studied to be a teacher, drew cartoons, and became the star pitcher for the school baseball team.

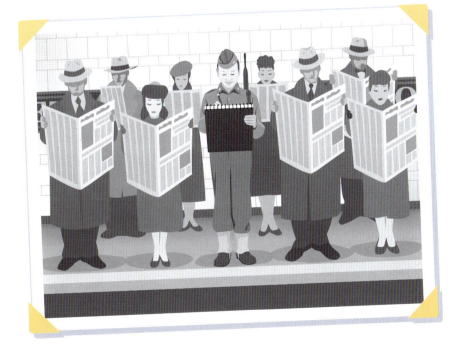

"After I finished school, I worked for a while in New York and then joined the Army. While I was in the Army, I helped to guard the subways in New York City. I never quit drawing, though!"

Mr. Bearden then explains, "It wasn't too long before I went to France, Italy, and Spain to study art. That was a fun year!

"When I returned to New York, I had to go to work, but I also met with artists and did lots of drawing with them," says Mister Bearden.

"Later, I started a music company and wrote some music," Mister Bearden says. "Some of the music was used in an ad!

"Not long after that I met a dancer named Nanette. She and I soon married.

"Because Nanette is a dancer, music is important to both of us.

"Maybe you'd like to see some of my collages about music," suggests Mister Bearden.

"I would like that very much!"

"This is the *Three Folk Musicians,*" says Mister Bearden as he points to a collage. "Why don't you tell me what you see?"

Puffer takes a long moment to look at the collage before he speaks. "First, I see three men holding musical instruments.

"If I look very, very closely, I see an old red building, a bit of a wire fence, and some tiny white daisies. A round, orange sun is in a clear blue sky.

"What I do *not* see are crowded streets or fancy clothes.

"These clues tell me that these men might live in the country and they play music for fun."

"Very good!" Mister Bearden tells Puffer.

"Now, I have a question for you, Mister Bearden. The banjo player looks like someone I know. Who is he?"

Mister Bearden laughs. "Some people say that the banjo player looks like me!"

Puffer laughs, too. "Maybe so!"

"Now, would you like to see a collage that shows a very different kind of music?"

"Yes, please!"

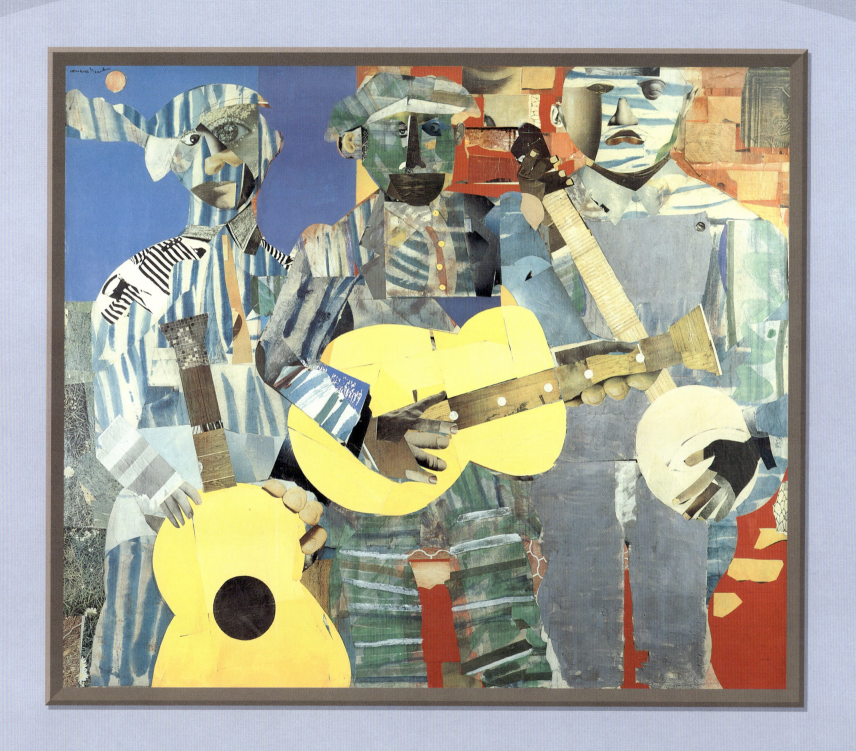

"I call this collage *Of the Blues: Showtime.* It's a picture about *blues* music," says Mister Bearden.

"What is blues music, Mister Bearden?"

"Blues is a kind of jazz. Blues music began in the southern United States. It became popular almost everywhere," Mister Bearden explains. "*Of the Blues: Showtime* is filled with clues that tell about blues music. What clues do you see?"

"I think that blues must have a lot of energy. See how the horn players and the singer are standing? Their arms are in the air and the instruments are pointed up. It looks as if they are dancing as they play the music."

"You are finding some good clues!" exclaims Mister Bearden.

Puffer continues. "I think that the musicians and singer are on a stage. There is a green curtain above them. And look! They have a microphone so that they can be heard by a large crowd."

Mister Bearden smiles and nods as if to say, "Yes."

"This is a special show. The men have on tuxedos and bow ties. The lady has on a fancy dress and jewelry."

Mister Bearden nods his head. "Ahhh—so you see that there *are* differences between folk music and the blues?"

"You bet! Your artwork shows what the music is about."

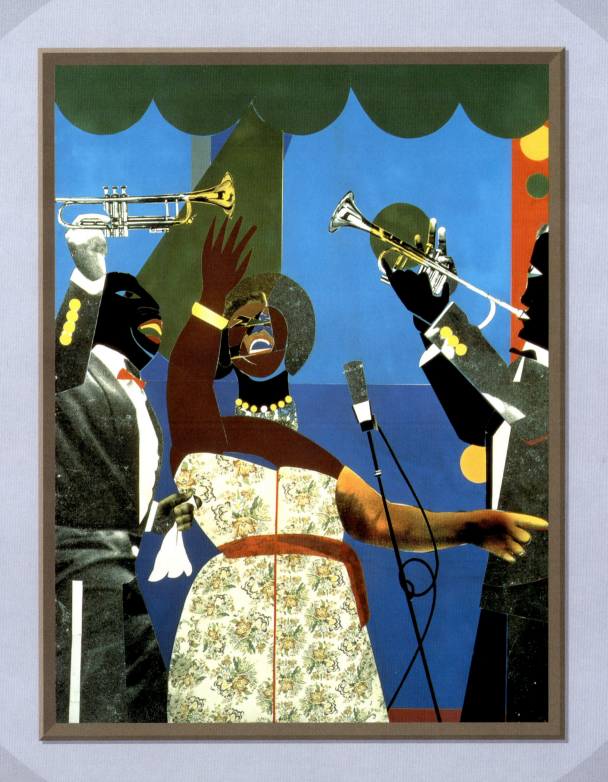

Puffer is surprised by a sudden noise.

Plink! Plink! Plinkity! Plink

"What's that?"

"That's just Gypo. He's jumped on the piano keys," laughs Mister Bearden. "Come here, you silly cat!"

Then Puffer sees the clock. "Thank you for a fun visit, Mister Bearden, but it is time for me to go."

The new friends say good-bye and wave as Puffer leaves Mister Bearden's studio.

"Meow!" says Gypo.

I hope you enjoyed dropping in on Romare Bearden. Learning about the different times, places, and reasons that artists make art help us to see the world around us in new or different ways.

The next time you see a work of art by Romare Bearden, look closely and see if you can discover what the artwork is saying.

Good-bye for now!